Mounta...
Wa...

The bleak white-capped peaks of Snowdonia; the autumn-yellow woodland slopes of the Brecon Beacons; the angry red crags of Cadair Idris under a fiery sun... the diverse beauty of Wales's mountains is captured here in a stunning series of photographs. Written by Rhodri Owen. Published by Graffeg.

Contents

GRAFFEG

Introduction

It's hard to think of an environmental feature of Wales more central to its history, nature and economy than its mountains. Where once, long ago, the native Welsh sought out their magnificent peaks to evade advancing Roman legions, now armies of adventurers from around the globe beat a path to Snowdonia or the Brecon Beacons in the name of outdoor pursuits such as rock climbing, hill walking, mountain biking, hang gliding or survival training.

From the Glyderau to the Preselis, the Black Mountains to the Berwyns, there are some 19 mountain ranges packed within Wales's modest 20,000 square kilometres, amounting to hundreds of peaks – some famous and well-trodden, but many more unspoilt and waiting to be discovered.

The home of the 15 'Welsh 3,000s', all to be found in Snowdonia and all capable of being 'bagged' within 24 hours, Wales also boasts 137 'Hewitts' (mountains over 2,000ft/609m with a relative height of 98ft/30m). Add to this its 189 'Nuttalls' (mountains over 2,000ft/609m that rise on all sides by at least 50ft/15m) and 156 'Marilyns' (those that rise to a relative height of at least 492ft/150m) and you have a backpackers' paradise.

In pictures and words this mini book offers a taste of the wealth and diversity of the mountains of Wales and confirms the truism that you don't need to be a vigorous outdoor type to take pleasure in their splendour.

The Black Mountain, Carmarthenshire
Often confused with the Black Mountains in southeast Wales, the Black Mountain range rises in the west of Brecon Beacons National Park between Ammanford and Sennybridge. Its highest point, Fan Brycheiniog (2631ft, 802m), looks down over Llyn y Fan Fawr, famous in Welsh folklore for the Lady of the Lake. According to the legend a beautiful woman rose from the water and married a local farmer, returning to the deep when he inflicted 'three causeless blows' upon her.

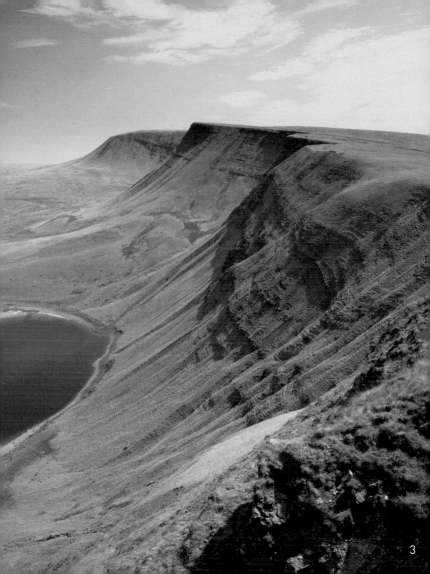

Waun Rydd

Waun Rydd (2,523ft, 769m) lies
to the east of Pen y Fan, Corn
Du and Cribyn on the ridge of
the Beacons south of Brecon.
Above the tree line lies a
featureless moorland plateau
with a summit cairn, Carn Pica,
at its eastern end. The mountain
bears a memorial to five young
Canadian aircrew whose
Wellington bomber crashed
here in poor weather conditions
on 6 July 1942, during a flight
from their base at Wellesbourne
Mountford near Stratford-
upon-Avon.

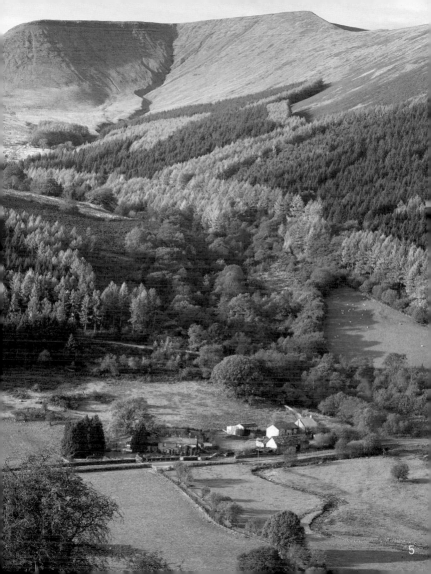

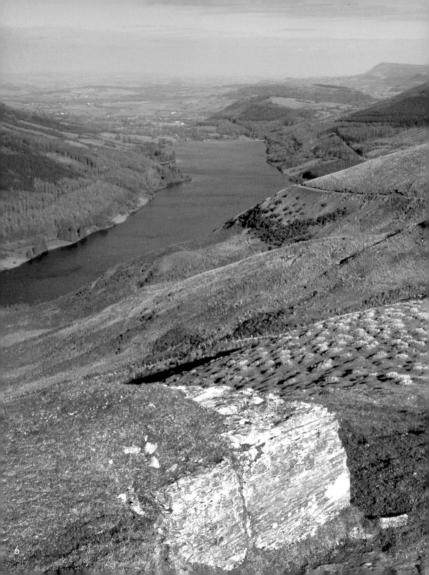

Talybont Reservoir
Built between the two World Wars to provide water for Newport. At 318 acres and 3km in length, Talybont Reservoir is the largest stillwater reservoir in the Brecon Beacons. Situated 8km south of Brecon and surrounded by hill slopes, farmland and forestry, in season the reservoir is popular with fly fishing enthusiasts and canoeists. As a traffic-free stretch of the Taff Trail passes *en route* from Cardiff to Brecon, its shores are also a magnet for walkers and cyclists.

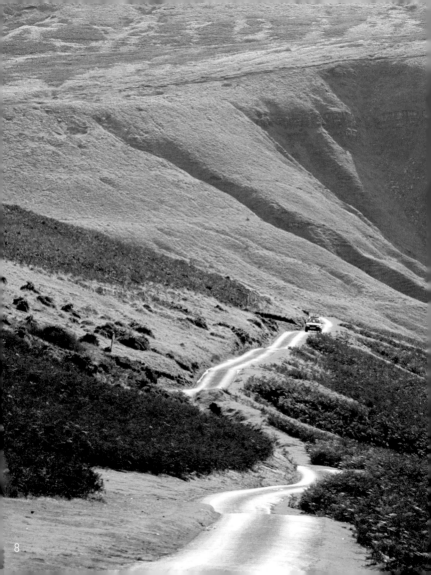

The Black Mountains

These stretch across the easternmost part of the Brecon Beacons National Park, from Monmouthshire into Herefordshire. Alongside Sugar Loaf and Ysgyryd Fawr (The Skirrid), Waun Fach (2,661ft, 811m) tops a range of peaks which inspired local Welsh writer Raymond Williams to pen *People of the Black Mountains* and provided the setting for Bruce Chatwin's award-winning novel *On The Black Hill*. Among the lanes and bridlepaths which criss-cross the landscape here is the Offa's Dyke long distance footpath.

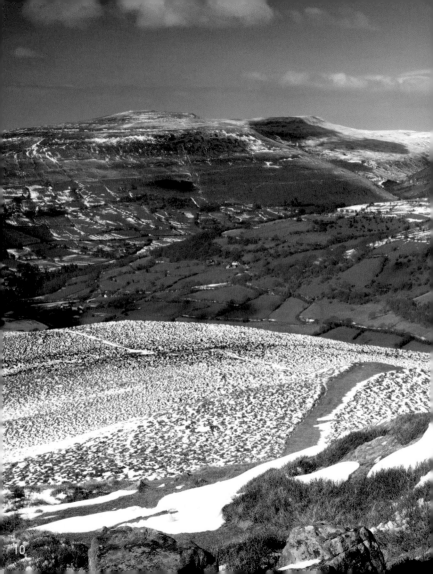

View to Black Mountains from Sugar Loaf Mountain

The wooded slopes of Sugar Loaf (1,960ft, 598m), one of the summit peaks of the Black Mountains northwest of Abergavenny, have been deemed a Site of Special Scientific Interest. During the 1990s prehistoric flint tools were found on a nearby foothill, Y Graig. Currently in the hands of the National Trust, the conical-topped Sugar Loaf is grazed by sheep during the summer months but remains a popular attraction for hill walkers all year round.

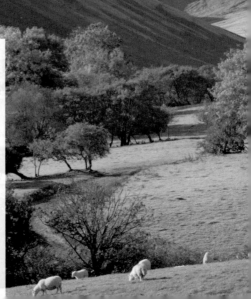

Pen y Fan

Sheep may safely graze but Pen y Fan has an altogether more treacherous reputation among Britain's armed forces. The mountain lies at the heart of the notorious 'fan dance' fitness and navigation exercise, part of the unforgiving selection course for the world famous Special Air Service regiment. Carrying a 35lb backpack, candidates are required to reach the summit of the mountain, walk down the other side, then promptly repeat the feat in reverse – and all against the clock.

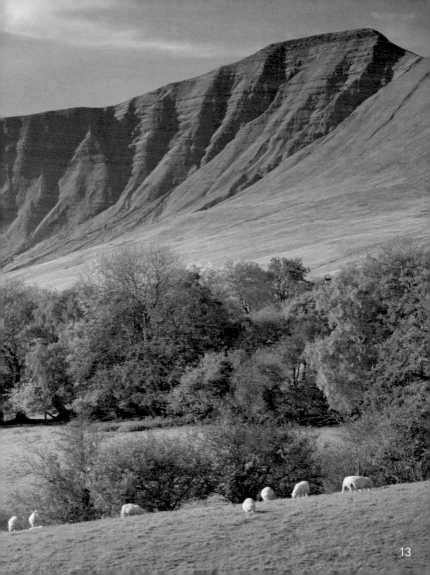

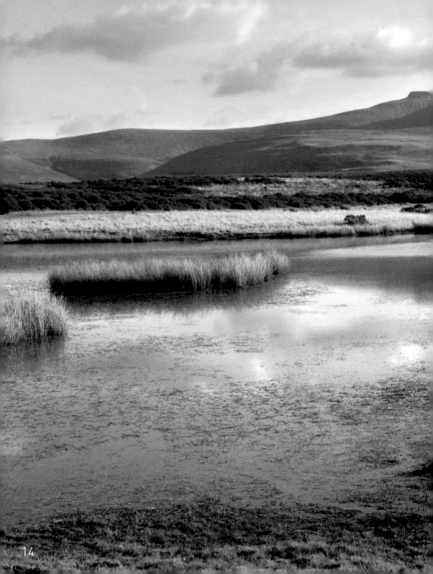

Pen y Fan and Corn Du Mountains from Mynydd Illtyd Common

Rising next to the A470 between Merthyr Tydfil and Brecon, Pen y Fan (2,907ft, 886m), alongside its add-on summit Corn Du (2,864ft, 873m), is the largest British peak south of Snowdonia. A popular mountain for walkers of all abilities, the route from Storey Arms to the summit passes a reminder of its ever-present danger – a memorial to Tommy Jones, the four-year-old son of a Rhondda coalminer who lost his way while visiting his grandparents on 4 August 1900.

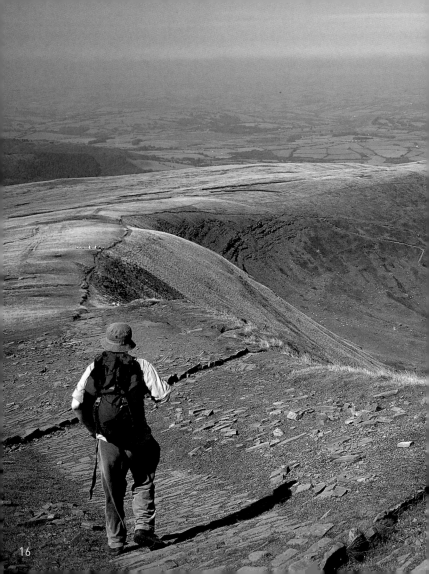

Walker on Craig Cwm Llwch leading away from Corn Du
The ridge of Cwm Llwch, connecting Corn Du and Pen y Fan in the Brecon Beacons, drops away steeply towards Llyn Cwm Llwch. Like many lakes in Wales, Cwm Llwch is soaked in mythology. Once a year, it is said, a secret door opens up here, providing a passage to a fairy realm. Another legend describes an old lady trying to lure 900 mortals into the deep with music in order to regain her youth and beauty.

Cambrian Mountains over Nant y Moch Reservoir

Once used as a catch-all name for the larger mountains of Wales, the Cambrian Mountains refers today to those stretching across mid Wales from Carmarthenshire in the south, through Ceredigion towards Snowdonia to the north. An unspoilt area of landscape sometimes referred to as 'the green desert of Wales', the Cambrians consist largely of moorland and hill farm. The highest peak in the range is Pen Pumlumon Fawr (2,467ft, 752m), more commonly known as Plynlimon.

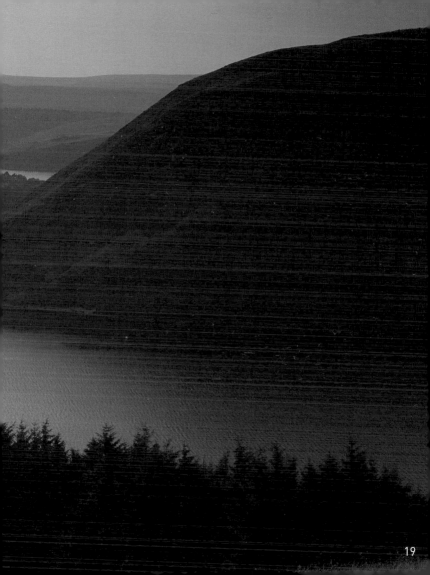

Cadair Idris

'Tongues of fire on Idris flaring'* – one of Wales's most popular mountains, Cadair Idris (2,930ft, 893m), an 11km ridge in southern Snowdonia, takes its name from Idris, the giant poet, astronomer and philosopher of Welsh mythology, and the seat-like shape of Cwm Cau on the side of the mountain. Swathed in legend, it is said that anyone who sleeps on the mountain will awaken either a madman or a poet. (*From *Men of Harlech*)

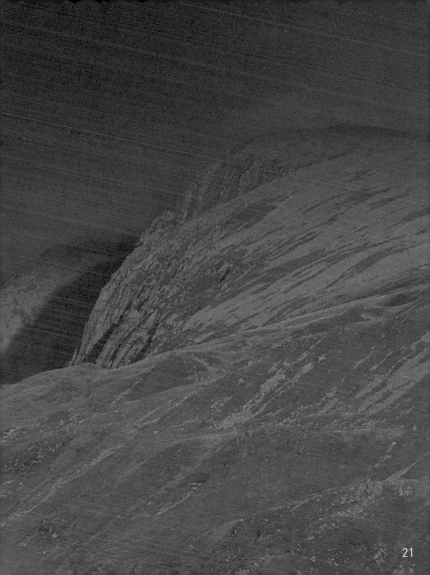

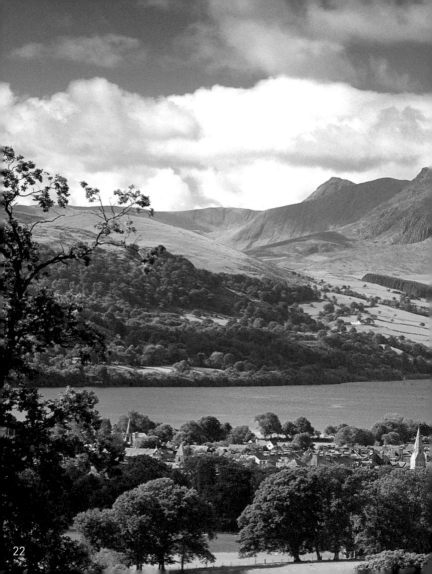

Aran Fawddwy viewed over Bala Lake

Aran Fawddwy (2,976ft, 907m) near Dolgellau is the tallest mountain in southern Snowdonia and one of half a dozen Aran peaks stretching north to south along the Dyfi Valley. Despite being taller than the popular Cadair Idris and Pen y Fan to the south, its relatively remote location means that it offers a far more peaceful and undisturbed environment for the discerning hill climber. Aran Fawddwy is the source of the River Dyfi.

Snowdon

Odd though it may sound, recorded snowfall on Snowdon (3,560ft, 1,085m) dropped by 55 per cent between 1994 and 2004. The highest peak in England and Wales, Yr Wyddfa ('the tomb') as it is known in Welsh, is the people's mountain – largely because of its easy accessibility in warmer months by train or on foot, but also due to a £3 million public subscription which allowed the National Trust to purchase key stretches of the mountain for the nation.

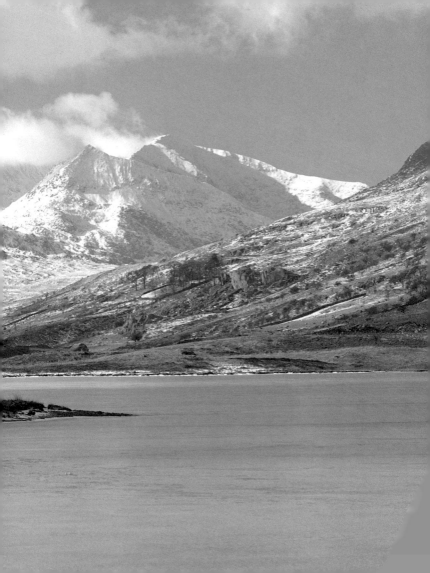

Snowdon Horseshoe from Capel Curig

The Snowdon Horseshoe seen in winter beyond Llynnau Mymbyr – a lake three-quarters of a mile long which has been dissected by a delta. Rising just a kilometre north of Snowdon, Garnedd Ugain (3494ft, 1065m) is the second highest peak in Wales. It is often referred to as Crib y Ddysgwl ('ridge of the dish'), although this name is also commonly used for the east ridge rather than the summit itself.

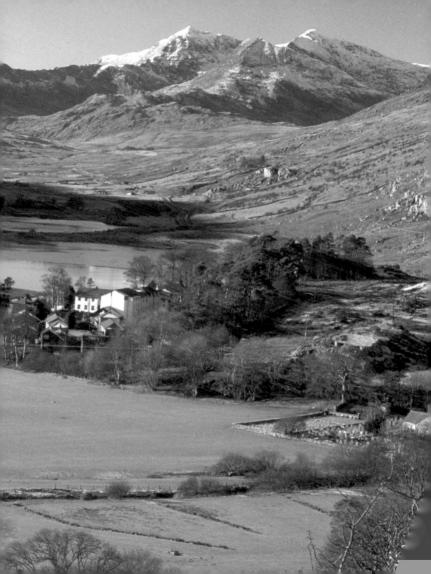

Snowdon from Crib Goch

The razor-edged ridge at Crib Goch (3,028ft, 923m) on the Snowdon Horseshoe is not for the inexperienced or the faint-hearted. From the Pen y Pass side, Crib Goch is the first peak on the classic Horseshoe traverse of Snowdon, a route which also takes in Crib y Ddysgl, Snowdon itself and Y Lliwedd. 'The red ridge' is classed as one of the 'Welsh 3000s', a 30-mile trek taking in 15 such summits which can be completed within 24 hours.

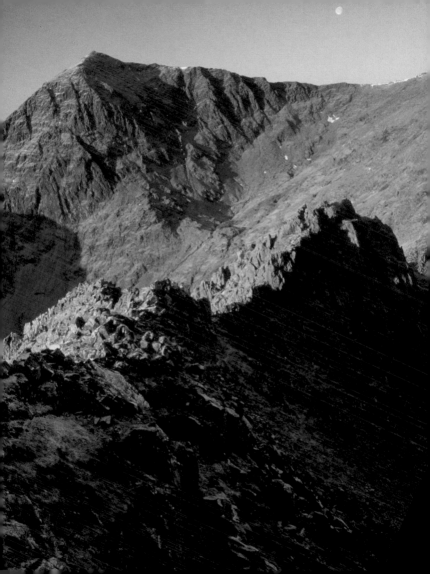

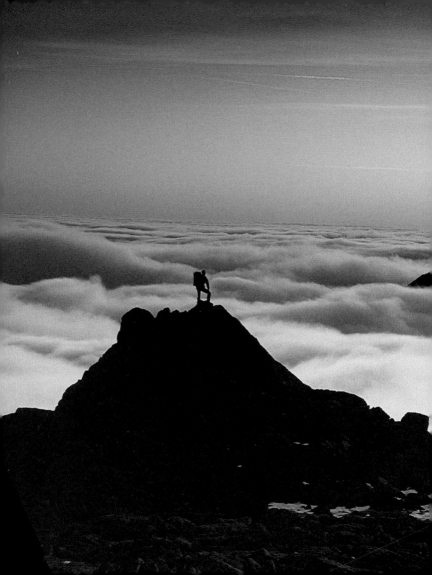

Lliwedd from Crib Goch

One of the peaks of the Snowdon Horseshoe, Y Lliwedd (2,946ft, 898m) occasionally rewards the early bird with a breathtaking carpet of mist at dawn. In 1909 this peak was the subject of *The Climbs on Lliwedd* by James Merriman Archer Thomson and Arthur Westlake Andrews, the first guide to climbing in Snowdonia. The book was published by the famous Climbers Club, one of the earliest rock-climbing clubs in England and Wales, which was founded just 11 years earlier.

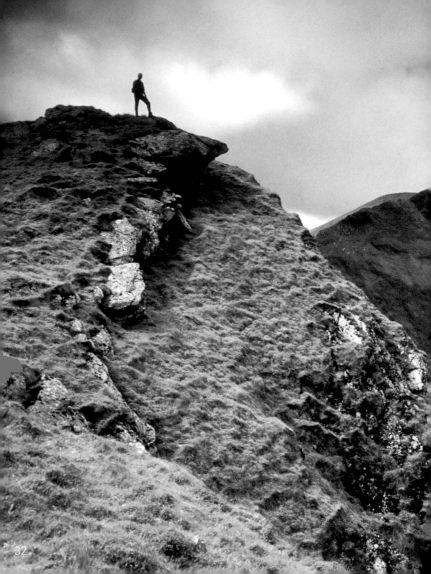

Mynydd Tal y Mignedd

At 2,142ft (653m) it forms part of the Nantlle Ridge which stretches over 9km from Rhyd-Ddu to Nebo and rewards the hill walker with stunning views of the Snowdon range and the Llyn Peninsula. At the top stands a slate obelisk built by the men of the Prince of Wales quarry to commemorate Queen Victoria's Diamond Jubilee. Somewhat less romantically, Mynydd Tal y Mignedd translates from the Welsh as 'Mountain at the end of the bog'.

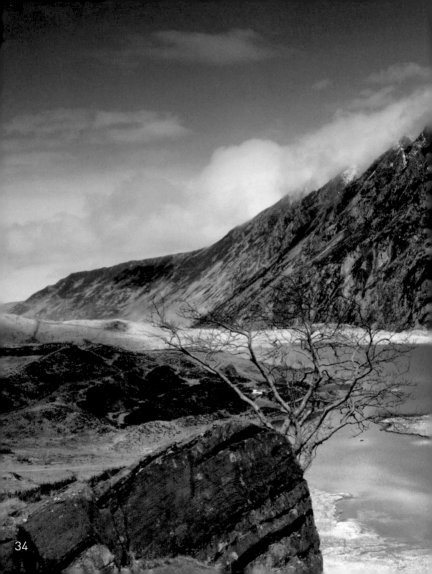

Cwm Idwal

This classic U-shaped valley in the Glyderau Mountains north of Snowdon is a magnet for rock climbers, hill walkers and botanists, and was recently voted the seventh greatest natural wonder in Britain. Charles Darwin is said to have visited the cwm, the most southerly place in Britain to find many arctic plants such as the Moss Campion (Silene acaulis) and a variety of alpine saxifrages. Climbers are lured by the Devil's Kitchen, a deep rock cleft resembling a chimney belching clouds.

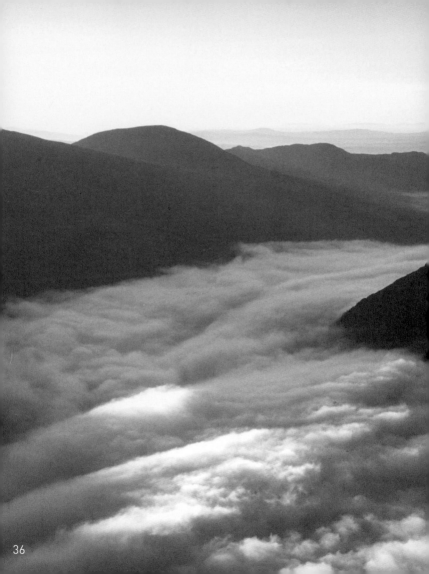

Tryfan

As its craggy spine suggests, any route up Tryfan (3,002ft, 915m), part of the Glyderau range north of Snowdon, will involve a scramble to challenge any hill walker. At the top the successful will find the notorious Adam and Eve – two boulders set a few feet apart with an off-putting fall between them. If the wind and rain allows, it is traditional to jump from one to the other in order to gain 'the Freedom of Tryfan'.

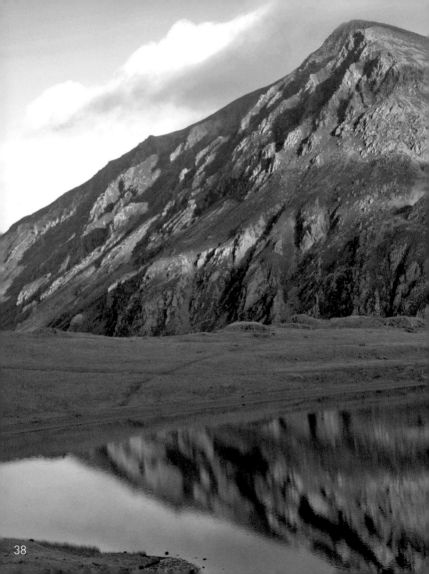

Pen yr Ole Wen
This is the most southerly mountain in Snowdonia's Carneddau range (3,209ft, 978m) and on a clear day provides striking views of Snowdon, the Glyderau and nearby Cwm Idwal. Traditionally translated from the Welsh as 'head of the white light', the mountain's name has been debated in recent years. Since an intervention by language experts at Bangor University it is now translated as 'head of the white slope'.

Y Garn

Not to be mistaken with the peak of the same name that rises above Coed y Brenin in the Rhinogydd range of southern Snowdonia, Y Garn (3,107ft, 947m) in the Glyderau group rises like an armchair above Llyn Ogwen, said to be the resting place of King Arthur's sword Excalibur. The more adventurous hill walker will descend Y Garn after crossing from Tryfan and the Glyders, Fawr and Fach – a 13km route described as 'very hard'.

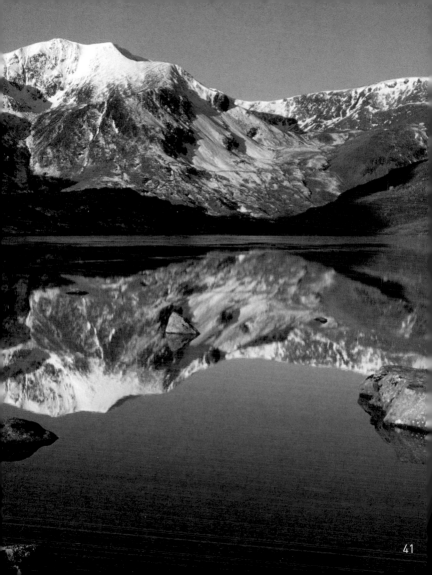

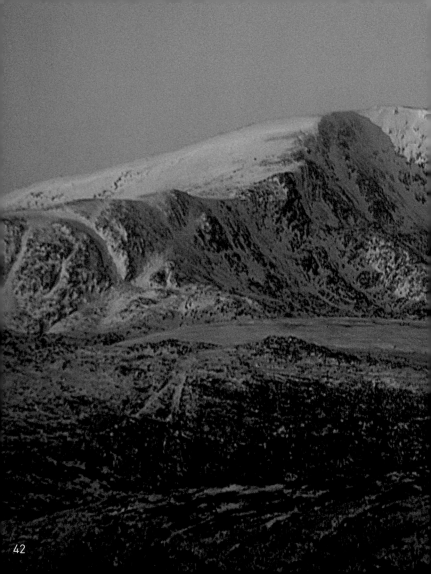

Carnedd Llewelyn

Literally 'Llywelyn's cairn',
the name of Wales's third
highest mountain, Carnedd
Llewelyn (3,491ft, 1064m),
is also a source of some
confusion. According to some,
it commemorates Llywelyn ap
Gruffudd, the last native Prince
of Wales before Edward I's
conquest, while neighbouring
Carnedd Dafydd (3,425ft,
1044m) refers to his brother.
To others these two peaks refer
to the earlier Welsh prince,
Llywelyn ab Iorwerth (Llywelyn
Mawr), and his son Dafydd.

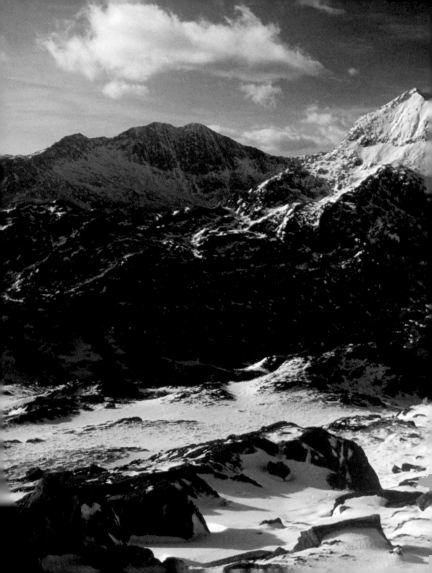

Glyder Fawr

The highest point of the Glyderau range, Glyder Fawr (3,278ft, 999m) with its rocky crags and scree slopes is perhaps better suited to climbers than walkers, though some routes make for easier walking and scrambling than others. Along with its sister summits Glyder Fach, Y Garn, Elidir Fawr and Tryfan, Glyder Fawr makes up the five peaks in the group over 3,000ft. Each is accessible from either the Ogwen Valley or the Llanberis Pass.

**Llanberis Pass
mountain wall**
With its topography and
climate, Snowdonia has played
a significant role in the history
of rock climbing since the
Victorian era, proving a popular
pre-Everest training ground
for renowned climbers from
George Mallory to Edmund
Hillary and Chris Bonington.
For more than 150 years the
snowy crags and sheer walls
of Snowdonia have succumbed
one by one in the face of
increasingly sophisticated
climbing techniques and
equipment – not to mention
bare-faced nerve.

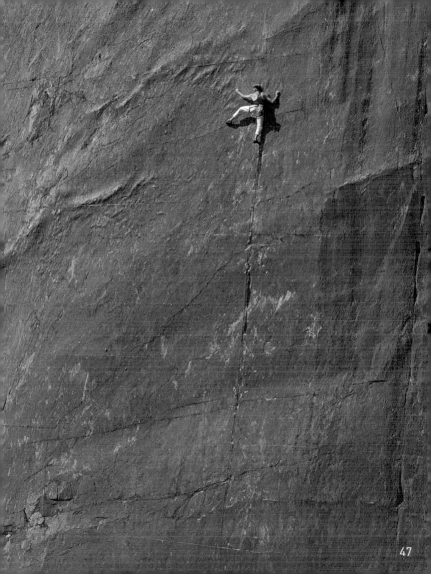

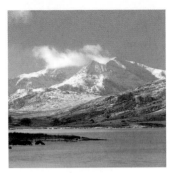

Cover: Snowdon from
Capel Curig
Photo: Pierino Algieri,
© PhotolibraryWales.com.

Useful websites

www.visitwales.co.uk
www.ccw.gov.uk (National Trails)
www.snowdonia-npa.gov.uk
(Snowdonia National Park)
www.pembrokeshirecoast.org
(Pembrokeshire National Park)
www.visitbreconbeacons.org
(Brecon Beacons National Park)
www.photolibrarywales.co.uk
www.tourwales.org.uk
www.cadw.wales.gov.uk
www.nationaltrust.org.uk
www.graffeg.com

Published by Graffeg
First published 2008
© Graffeg 2008
ISBN 9781905582280

Graffeg, Radnor Court,
256 Cowbridge Road East,
Cardiff CF5 1GZ Wales UK.
www.graffeg.com
are hereby identified as the authors
of this work in accordance with
section 77 of the Copyrights,
Designs and Patents Act 1988.

A CIP Catalogue record for this book
is available from the British Library.

Designed and produced by Peter Gill
& Associates www.petergill.com

Picture credits
© britainonview: 8 / Andy Stothert: 3,
18 / Graham Bell: inside front cover, 6,
10, 16 / James Osmond: 28 / NTPL /Joe
Cornish: 40. © PhotolibraryWales.com:
4, 12, 14, 20, 22, 24, 26, 30, 32, 34, 36, 38,
42, 44, 46, inside back cover.

www.graffeg.com tel: 029 2037 7312